INUVIK IN PICTURES
1958 – 2008

COMPILED AND EDITED
BY DICK HILL AND BART KREPS

From left: the official Inuvik logo includes a light green teepee representing the Dene, the igloo representing the Inuit and the dark green house representing the non-natives who live in Inuvik. The logo of the Gwich'in Tribal Council depicts a caribou. The Inuvialuit Regional Corporation logo is a gyrfalcon. The official logo for the Inuvik 50th Anniversary, drawn by Curtis Naphan, is inspired by the original town logo, and is done in gold both as the traditional colour for 50th anniversaries and to symbolise optimism in the land of the midnight sun.

Dick Hill moved to Inuvik with his family in 1963 and spent 33 years there. He served as the director of the Inuvik Research Laboratory and was the Town's first Mayor. He was active in many community organizations including the Chamber of Commerce, the Territorial Experimental Ski Training program, the University of Canada North and the Western Arctic Tourism Association. On retiring, he donated his substantial collection of northern books to the Inuvik Centennial Library. *Inuvik in Pictures*, a companion volume to *Inuvik: A History*, is published to mark the 50th birthday of this planned arctic community.

Except where otherwise noted, photographs are by Dick Hill.

Editing, design and layout by Bart Kreps.

Contact Dick Hill at 43 Niagara St., Collingwood ON L9Y 3X1, or email to dickhill@rogers.com for any corrections or suggestions.

ISBN 978-1-4251-4463-0 (sc)

Order this book online at www.trafford.com
or email orders@trafford.com

Note for Librarians: A cataloguing record for this book is available from Library and Archives Canada at www.collectionscanada.ca/amicus/index-e.html

Printed in Victoria, BC, Canada. Order this book online at www.trafford.com/07-1882 or email orders@trafford.com. Most Trafford titles are also available at major online book retailers.

Trafford rev. 04/17/2019

Trafford PUBLISHING® www.trafford.com
North America & international
toll-free: 1 888 232 4444 (USA & Canada)
fax: 812 355 4082

Front Cover photographs: top, raising the first large warehouse, 1956, photo by Curtis Merrill, NWT Archives/N-1992-192: 0219. Bottom left: Prime Minister and Mrs. Diefenbaker in Inuvik, 1961, NWT Archives/ N-1993-002: 0480. Bottom centre: civil servant housing, photo courtesy of Dr. N.E. Hunt Collection, Inuvik Centennial Library. Bottom right: Bill Nasogaluak at the Great Northern Arts Festival, 1992, photo by Tessa Mcintosh, NWT Archives/ G-1995-001: 7764.

Back Cover photographs: top row, left to right, Johnny Semple; Peggy Curtis; Nap Norbert; Cece McCauley; Rose Anne Allen. Second row, Cynthia Hill; unidentified; Martha Kupfer; unidentified. Third row, Billy Day, Doug Billingsley, Diane Baxter. Fourth row, Peter Clarkson, Victor Allen. Fifth row, Louis Goose.

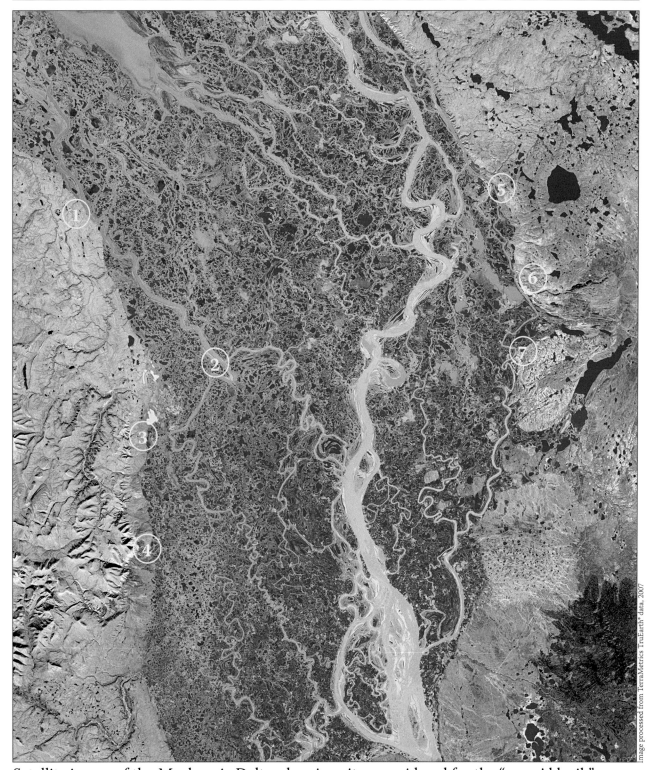

Satellite image of the Mackenzie Delta, showing sites considered for the "new Aklavik"

1: *"Fraserville" Site.* **2**: *Aklavik.* **3**: *West 1/Husky Site.* **4**: *West 2/Black Mountain Site.* **5**: *East 4/ Reindeer Hills Site.* **6**: *East 3/Inuvik.* **7**: *Big Rock Site.*

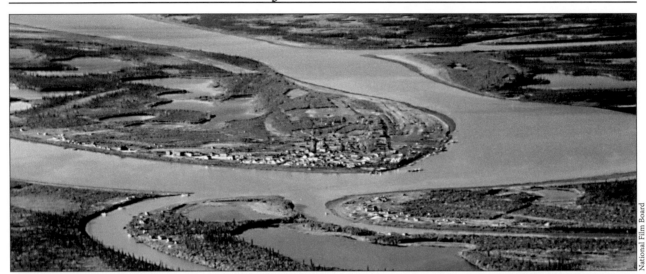

National Film Board

Aklavik was established in 1918 as a fur-trading post in the heart of the Mackenzie Delta. But as it grew into an administrative centre, its flood-prone location proved a major handicap, and resources such as gravel for good roads and an airport were not easily accessible.

In the early 1950s, a decision was made to seek a new site for Aklavik, and the new town was later named Inuvik. But many of Aklavik's residents chose not to move, and today Aklavik is approximately the same size as it was in the 1950s.

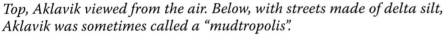

Top, Aklavik viewed from the air. Below, with streets made of delta silt, Aklavik was sometimes called a "mudtropolis".

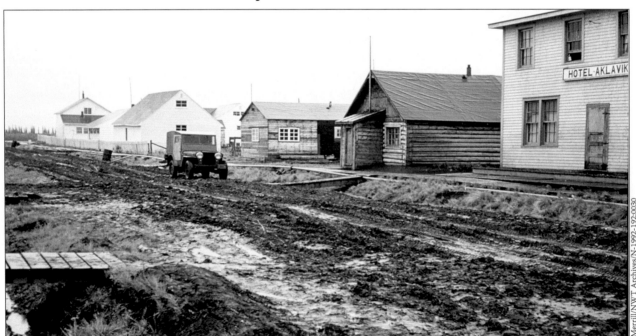

Merrill/NWT Archives/N-1992-192:0030

Several criteria were essential for a new town site. The site should be high enough in elevation to escape the frequent delta floods, there should be adequate gravel sources nearby, and the terrain should allow for the construction of a runway usable by modern large aircraft. Ten sites were considered, but only four were actually investigated – two on the west side and two on the east side of the Mackenzie Delta. The location known as East 3 was chosen, and detailed surveys took place during the summer of 1954.

At right, John Pihlainen, one of the search team members, at the Husky site, west of Aklavik, in April 1954.

Below, the survey team's tent camp at the East 3 site in 1954. The camp was set up on a gravel knoll which served as a natural dock. Clearing of willow brush had already begun around the camp.

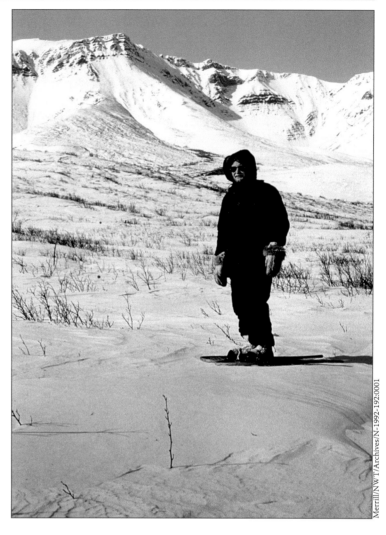

Merrill/NWT/Archives/N-1992-192:0001

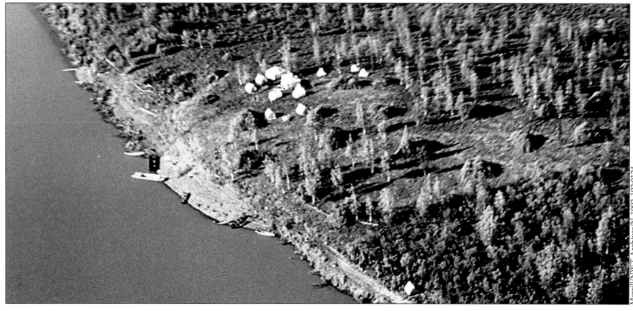

Merrill/NWT Archives/N-1992-192:0124

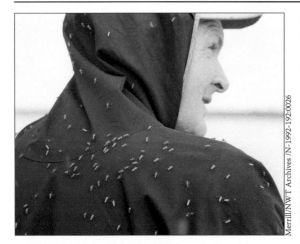

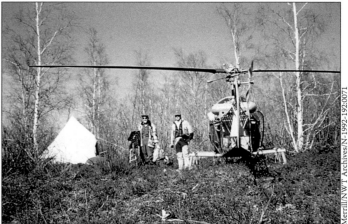

After the survey team had made detailed notes about elevation contours, vegetation cover, and gravel sources, Foundation of Canada Engineering Corporation Limited (FENCO) drew up a detailed town plan, labeled "Re-Siting of Aklavik", in 1955 (see next page). The plan was accompanied by drawings for the proposed wharf, cross-sections of roads and utilidors, green belts, proposed electrical generating station, and other essential elements of a new town's infrastructure.

Above left, project manager Curt Merrill, who took many of these photographs, shows off some of the famous arctic mosquitos.

Below left, Dan McLeod, who was the main cook for the survey party.

Above right, a helicopter brings John Pihlainen and new supplies to Roger Brown, who had spent the spring of 1954 observing the breakup of ice on the Mackenzie's East Channel.

Below right, the survey party: Standing, left to right: Dan McLeod, cook; Hank Johnson, engineer, National Research Council Permafrost Unit; Curtis Merrill, Project Manager; John Carmichael, driller's assistant; Jack Grainge, Public Health Engineer; Roger Brown, NRC geographer. Seated: Ken Berry, engineering technician, Public Works; John Pihlainen, Officer-in-Charge, NRC Permafrost Unit; Ed Garret, Airport construction engineer; Keith Fraser, Geographer, Energy, Mines and Resources.

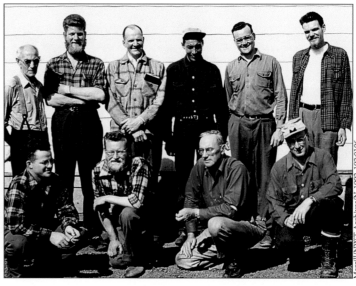

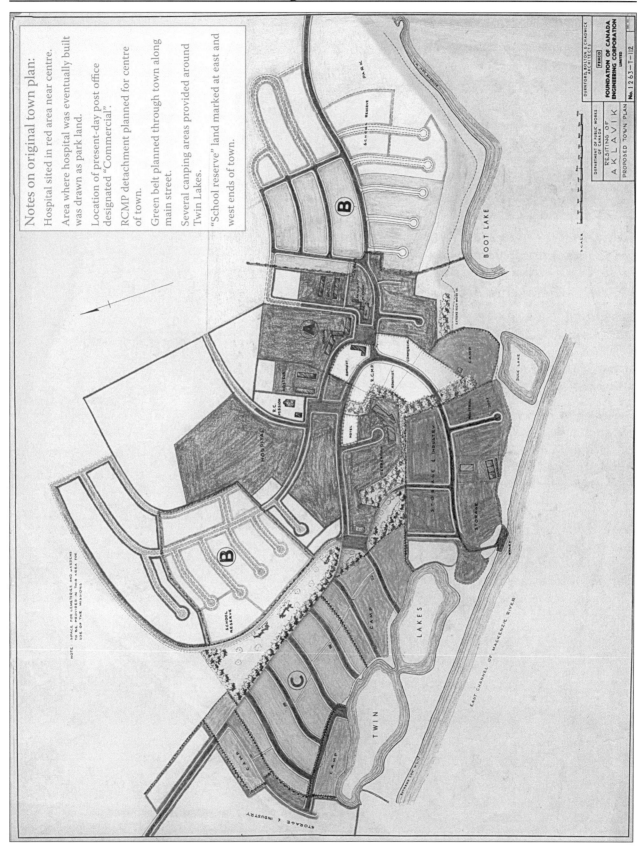

Notes on original town plan:

Hospital sited in red area near centre.

Area where hospital was eventually built was drawn as park land.

Location of present-day post office designated "Commercial".

RCMP detachment planned for centre of town.

Green belt planned through town along main street.

Several canping areas provided around Twin Lakes.

"School reserve" land marked at east and west ends of town.

Merrill/NWT Archives/N-1992-192:0129

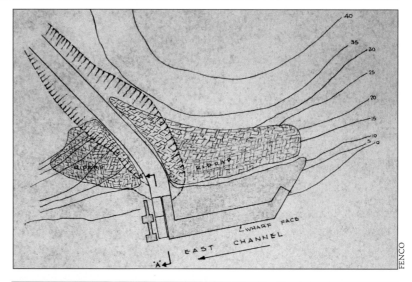

FENCO

Above, Aklavik enterpreneur Fred Norris, a veritable Department of Public works, owned a 5-ton truck, a D2 dozer, a tug boat and a barge.

Below, Adolph Koziesak, a trapper near Campbell Lake who became crew foreman in 1954 and 1955. Above right, the FENCO drawing for a wharf along the East Channel.

Centre right, Harry Harrison's schooner delivers a load of barrels salvaged from an abandoned military base at Kittigazuit; the barrels were used for many purposes including as culverts.

Below right: part of the building team. From left Curtis Merrill; John Gilbey, Department of Agriculture; Charlie Walrath, engineer; Frank Cunningham, Department of Northern Affairs.

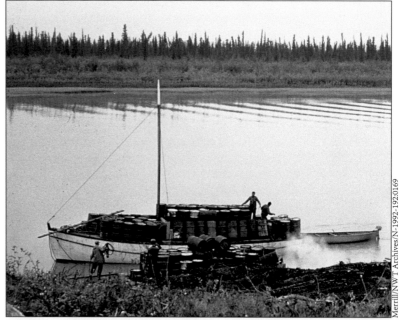

Merrill/NWT Archives/N-1992-192:0169

Merrill/NWT Archives/N-1992-192:0127

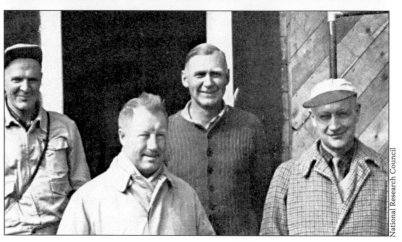

National Research Council

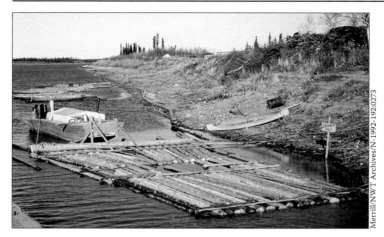

Logs were in great demand for many purposes, and were purchased and floated in from throughout the Mackenzie valley.

At left, a delivery by Buck Storr, a local trapper and entrepreneur.

Below left, Red Anders squares timbers to use as sills, on which to pile lumber being delivered from the Wood Buffalo National Park area.

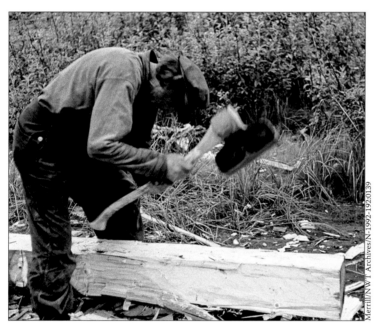

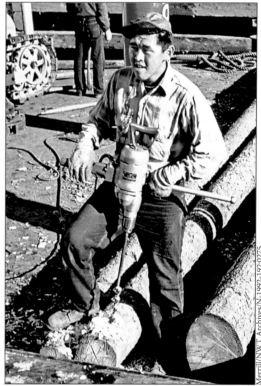

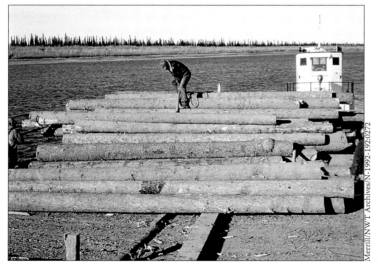

Above, Colin Allen works on boom timbers.

At left, Fred Norris and his tugboat "Barbara Jean" deliver a load of logs from Fort Good Hope.

Building on Permafrost

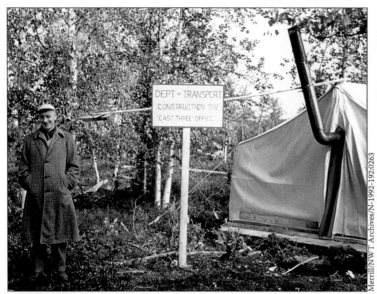

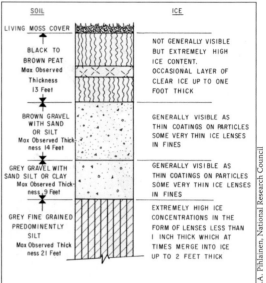

Road building on Inuvik's permafrost soils posed a particular challenge as much of the frozen subsoil had a high ice content and pure ice lens. Once the insulating layer of vegetation was disturbed, the ice underneath would melt, creating a bog. The crews had to develop new methods of ensuring that the permafrost in the sub-surface layers was not allowed to melt.

Above, Frank Cunningham outside the new Department of Transport office.

Below, large ice lens in the permafrost soil found while clearing gravel for road construction.

Above, John Pihlainen's diagram of the soil and ice mixtures that were typically found under the surface of the ground.

Below, a D8 tractor pulls a skid of logs along a trail in the springtime, when the surface layer was frozen solid.

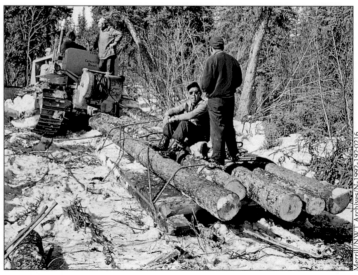

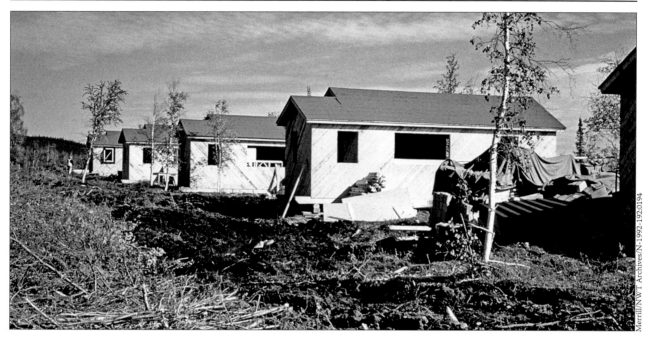

In July 1955, cabins were under construction so that workers could start to move out of the tent camps. The cabins were built to a 16 by 32 plan and were referred to as "512s" after the number of square feet. In the picture above, a temporary roadway has been constructed in front of the cabins through the placement of a thick layer of brush over the soil.

By September of 1955, pilings had been driven into the ground for the first large warehouse. A second warehouse was to be built on a large gravel pad just down slope, in an experiment to see if a large building could be built on the permafrost without pilings.

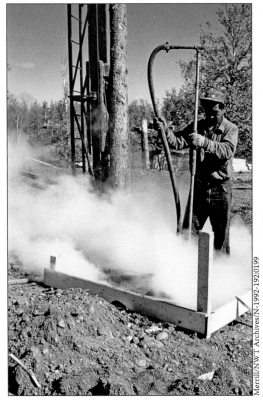

Merrill/NWT Archives/N-1992-192:0199

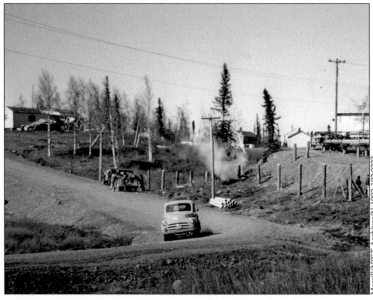

Merrill/NWT Archives/N-1992-192:0223

Most of the buildings in Inuvik are built on pilings which are driven into the permafrost.

Top left, Sam Arey operates the steam drill used to thaw the permafrost just enough to drive in the pilings. Above right, crews are steaming piles into the ground, as a DPW truck, travels down a new road. Centre left, Cliff Hagen of Arctic Red River was part of the early construction crew. Bottom left, Johnny Semple of Aklavik, was another early employee at East 3. Bottom right, a float is built on Hidden Lake, about a mile away from camp, and a siphon is set up to bring fresh clean drinking water to the camp.

Merrill/NWT Archives/N-1992-192:0128

Merrill/NWT Archives/N-1992-192:0209

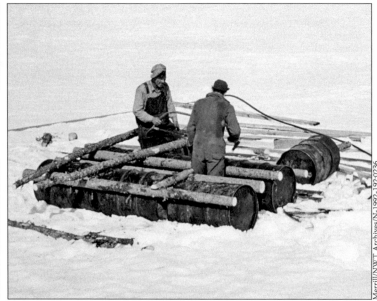

Merrill/NWT Archives/N-1992-192:0236

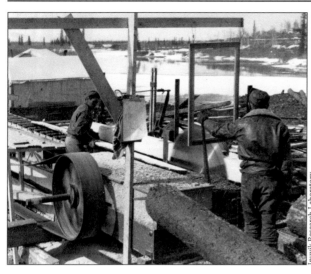

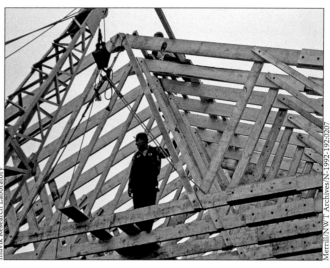

In 1955, a sawmill was set up, the first roads were built, and warehouses, a cookhouse and cabins for the construction crews were built. An air photo from May 1956 shows a new village, ready for an even busier construction season that summer.

Above left, the sawmill with Twin Lakes in the background. Above right, roof trusses are hoisted up to Nels Hvatum, a local trapper and carpenter.

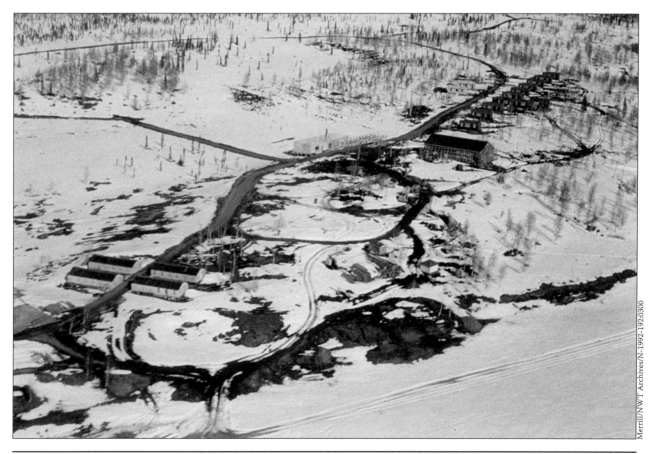

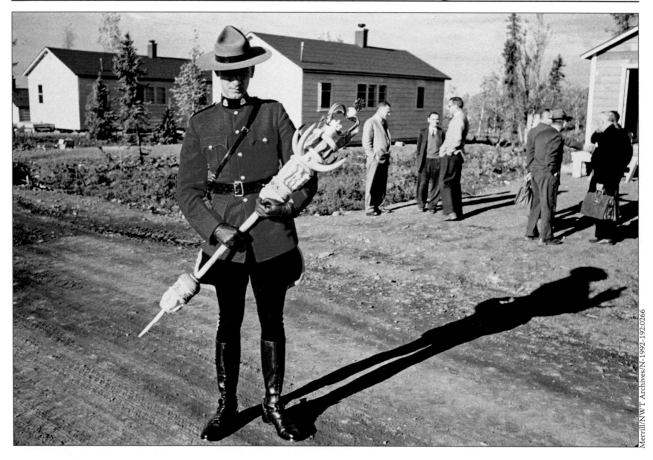

In August of 1956, East 3 hosted a meeting of the Territorial Council. The Council members were housed in newly constructed 512s near Boot Lake.

Above, an RCMP officer displays the official mace of the Council, with the Council Crescent cabins in the background. Below, Council Crescent from the air, in August 1956.

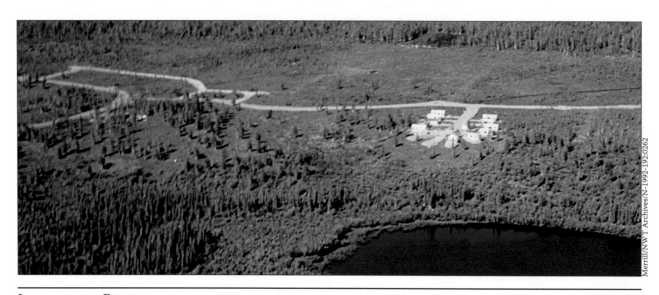

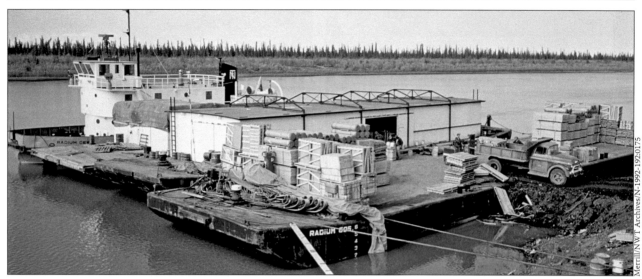

Construction of the major airport became an urgent priority. The initial plans called for a runway adjacent to East 3. The search for suitable soil conditions and topography then lead to a site along Long Lake, and finally the present location along Dolomite Lake was chosen.

Top, supplies are unloaded from the "Radium DEW" barge. Below, a gravel crushing plant was set up at the airport site to produce runway materials.

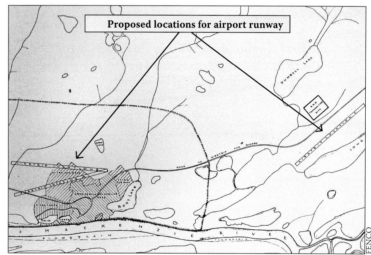

Proposed locations for airport runway

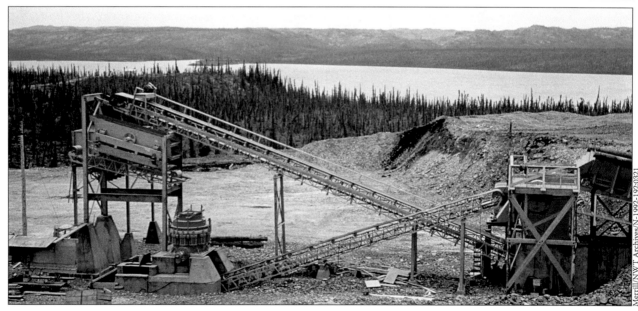

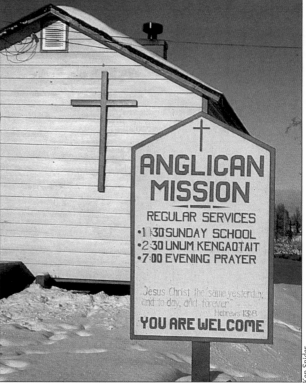

Above, the first school at East 3 was housed in this building on Distributor Street and went into operation in 1955.

Right, the first Anglican Mission in East 3, also on Distributor Street, was in operation in 1957.

Below left, Hebert and Emma Dick, and their sons Richard and Noel, lived in one of the new "512s" at East 3. Hebert was employed by Department of Public Works and also spent time trapping. The National Film Board caption for this photo refers to a "5 foot by 12 foot" cabin – a far cry from the actual 16´ x 32´ dimensions of a 512.

Below, the first bank at East 3 was also housed in a 512.

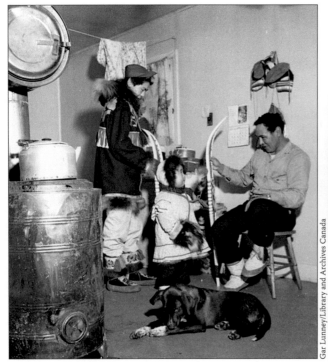

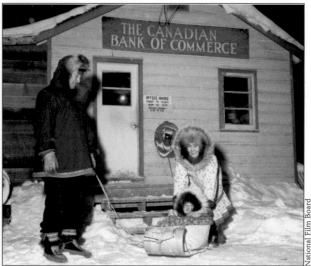

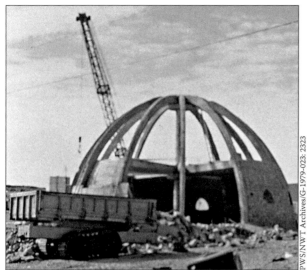

PWS/NWT Archives/G-1979-023: 2323

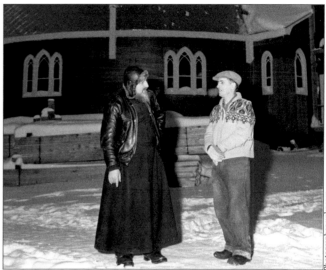

Photographer unknown

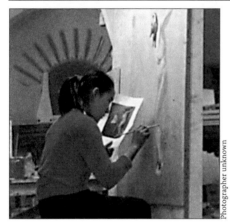

Photographer unknown

Inuvik's most famous landmark, Our Lady of Victory Church, is also known as the Igloo Church. It was designed by Brother Maurice Larocque and Father Joseph Adam, the local parish priest (at left in photo above). Neither man was a trained architect, and very little of the design was committed to paper until after the building was completed. The design made a conscious effort to blend Catholic symbolism with local traditions. Construction began near the end of 1958, and the church was dedicated on August 5, 1960.

Left, Mona Thrasher, a young Inuvialuit artist, painted 14 paintings in a Stations of the Cross series in the Church.

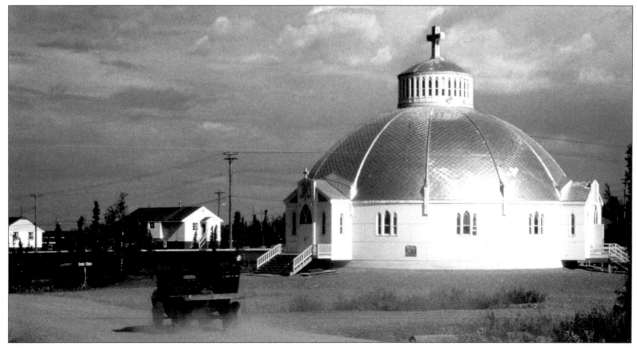

By 1959, a much larger school was opened, first called the Inuvik Federal School and later renamed Sir Alexander Mackenzie School. Hostel accommodation was built for students from neighbouring communities, and adult courses were also offered.

Below right, home economics teacher, Miss G. MacKay, offering instruction in dress-making, 1959.

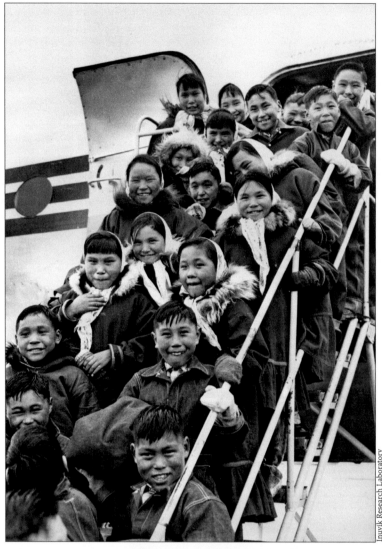

Inuvik Research Laboratory

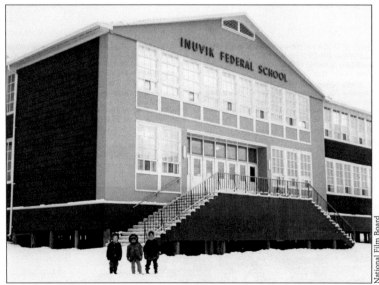

National Film Board

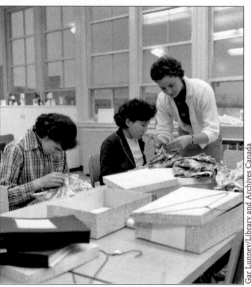

Gar Lunney/Library and Archives Canada

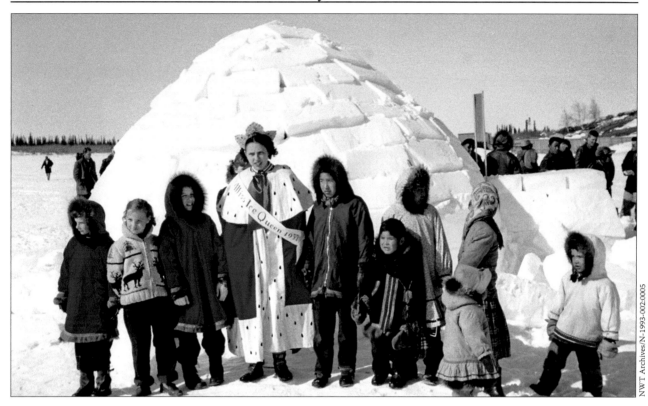

The new community's first Spring Carnival was held on the Mackenzie River in late April, 1957, with Florence Hagen named carnival queen (above). Below, herder Buster Kailek brought reindeer from Reindeer Station to offer sled rides. At right, Stan Peffer's recreation hall was constructed in 1958 and contained a pool hall, theatre and café. Below right, the Ice Worm queen during a 1960s carnival.

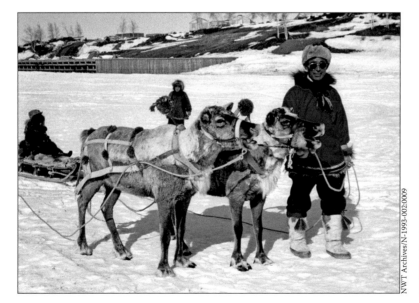

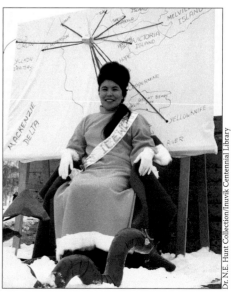

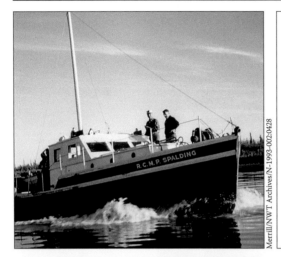

In 1958 the RCMP G division headquarters moved from Aklavik to Inuvik.

Above left, the RCMP Spalding on the Mackenzie River.

Above right, S/Cst. Andre Jerome on patrol from Arctic Red River (now Tsiigehtchic) to East 3, on April 21, 1957.

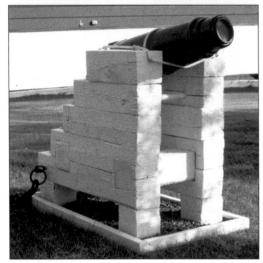

Left, a cannon which was originally located at the RCMP's Western Arctic base on Herschel Island, was moved to a location in front of the RCMP building in Inuvik.

Below, the RCMP Inuvik detachment in April of 1961: Cpl. Ed. Boone, Sgt. Scotty Stewart, Cst. Mert Mohr, Insp. Ed. Lysyk, Commissioner Harvision, Supt. Bill Fraser, Cst. Bob Knights, Cst. Lyle Trimble and Cst. Laurie Jamont.

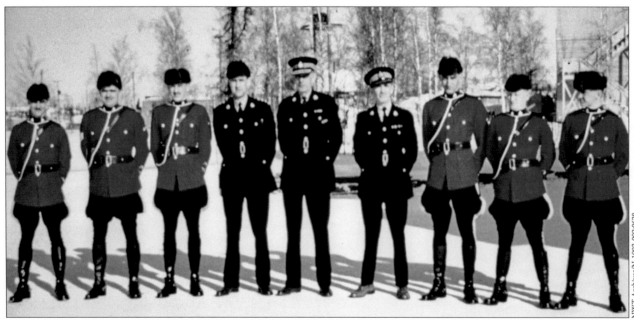

When Prime Minister John Diefenbaker was elected in 1957, a "Northern Vision" was part of his Conservative Party platform. The next five years saw a burst of federal activity in the far north, and Diefenbaker became the first serving Prime Minister to travel north of 60°. On July 20, 1961, he landed at Inuvik's new airport, and delivered a speech at the dedication of a new monument, representing Inuvik's three founding peoples – Inuit, Indian and others – working together to create a new community.

At right, Prime Minister and Mrs. Diefenbaker greet local children in front of the new monument, sculpted by Art Price of Ottawa.

Below, Vern Flexhaug, the Hudson's Bay Company manager, shaking hands with Prime Minister Diefenbaker as he arrives at the Inuvik Airport.

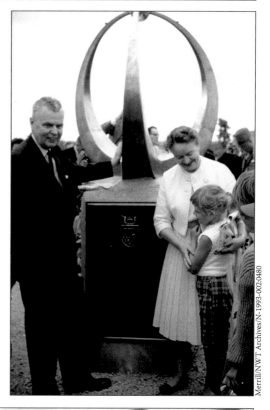

Merrill/NWT Archives/N-1993-002:0480

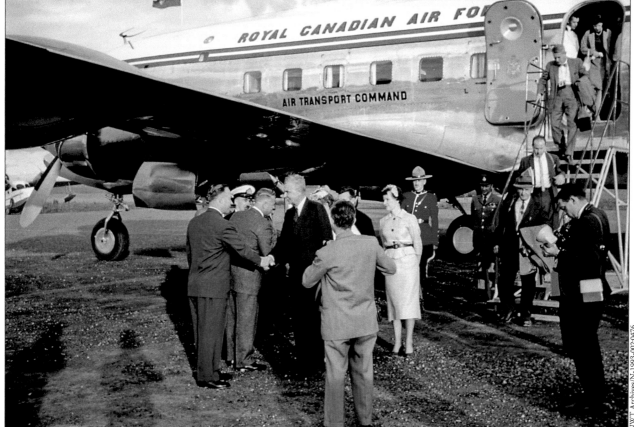

NWT Archives/N-1993-002:0476

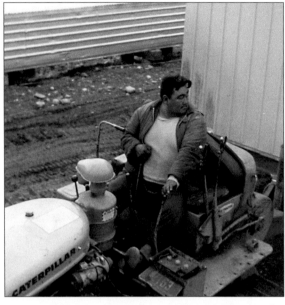

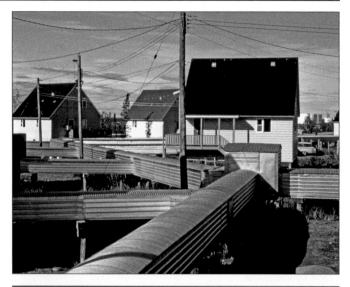

Most of the basic infrastructure of Inuvik, including the roads, utilities and housing stock, was completed by the 1970s.

Above, Peter Thrasher operating a Cat tractor during construction.

Centre right, a common summertime sight in Inuvik is bedroom windows covered with foil to block out the midnight sun.

Bottom right, a National Film Board photo from 1963 shows a residential district in the town's east end.

Below, Dave & Myrna Buttons' geodesic dome was one of the more unusual homes built during the 1970s.

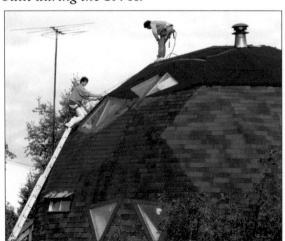

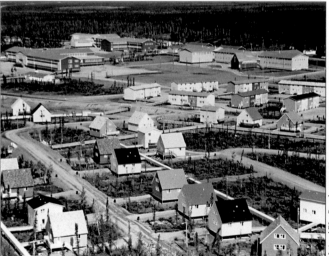

National Film Board

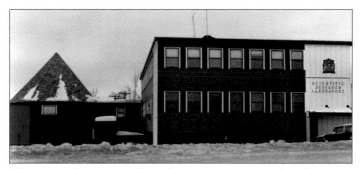
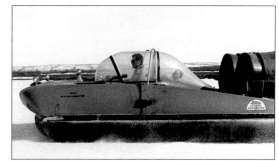

The Invuik Research Laboratory opened in late 1963 as a base for scientists in the physical, biological and social sciences. Its most distinctive feature was a cone-shaped tower housing a cosmic ray detector, which has been contributing for 40 years to an understanding of the interaction between deep-space radiation and sunspot cycles.

Above right, a hovercraft was one of the then-novel transportation methods brought to Inuvik for testing in the Mackenzie Delta.

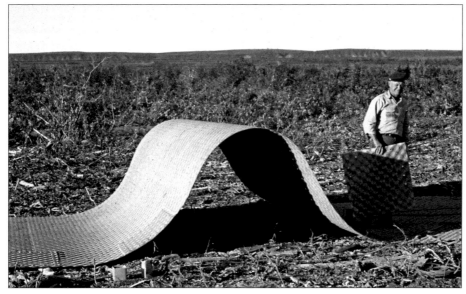

At left, a new form of durable textile was tested as a possible means to protect permafrost under roadways.

Researchers came to study the flora and fauna of the western Arctic, including peregrine falcons which nest on rocky cliffs a short way south of Inuvik.

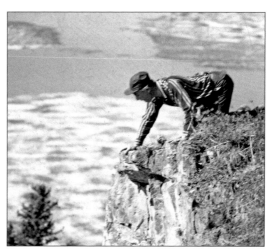

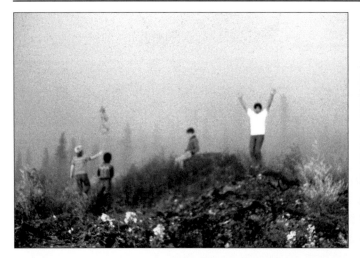

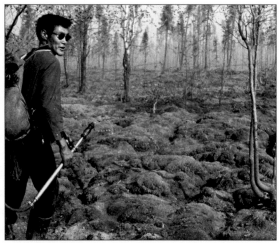

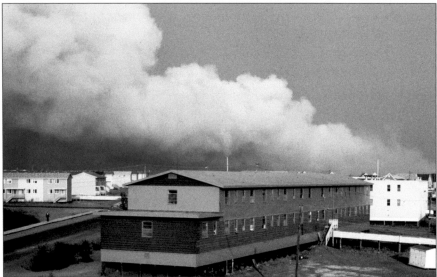

Inuvik has had its share of major fires. On August 8, 1968, a brush fire started along Airport Road, and a breeze from the southeast sent the fire speeding towards Inuvik. About 450 people, mostly volunteers, helped fight the fire and protect the town. But a wide swath to the east and north was burned, and decades later the effects were still clearly visible.

Below left, firefighters battled a blaze in -40° temperatures in 1966, as a hangar belonging to Arctic Wings & Rotors went up in flames. Below right, in 1983 a fire at the Northern Canada Power Corp. generating plant left the town reliant on an emergency generator system.

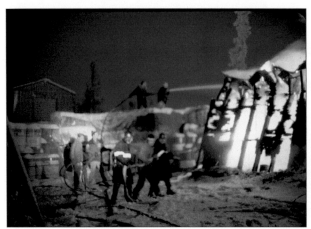

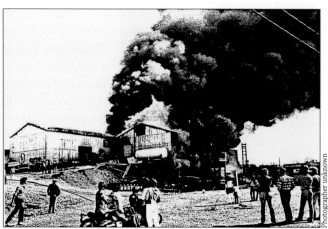

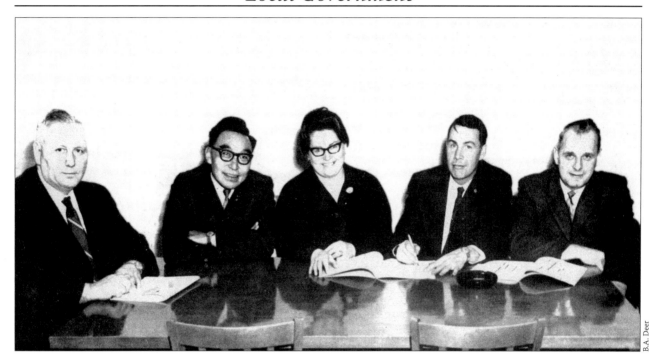

As Inuvik gradually acquired the full political functions of a municipality, a wide variety of people were involved in local government.

At top, the Village Council in 1968: Barney MacNeil, Elijah Menarik, Ellen Binder, Council Chairman D.S. Jones, Secretary-Manager D.W. Prowse.

Below, Suzie Huskie is sworn in as a Councillor, 1979.

Right, Councillor Frank Hansen is sworn in, 1972.

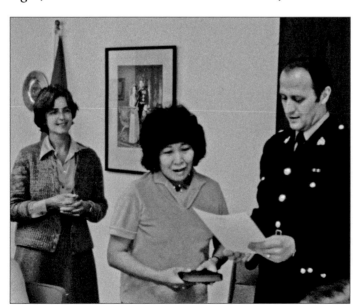

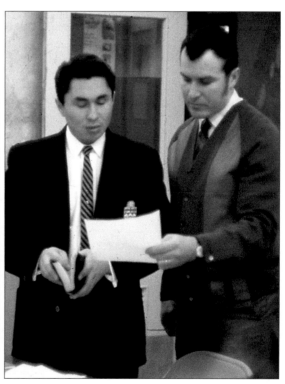

TOWN OF INUVIK

LUCHEON

AT THE FAMILY HALL

IN HONOUR OF THE VISIT OF

HER MAJESTY

QUEEN ELIZABETH II

THE PRINCE PHILIP, DUKE OF EDINBURGH

THE PRINCE OF WALES & PRINCESS ANNE

TUESDAY, 7th JULY 1970 RICHARD M. HILL, MAYOR

Menu

tomato juice

Arctic Char
Roast Caribou
Roast Reindeer
Potato Salad
Green Salad

Ice Cream

Cheese & Biscuits

Coffee

A highlight of the Northwest Territories' Centennial Celebration in 1970 was a royal visit. Queen Elizabeth II came to Inuvik for a luncheon on July 7, and stayed a day to greet residents and observe research projects.

Below left, the Queen, with Commissioner Stuart Hodgson, at an official greeting ceremony outside Sir Alexander Mackenzie School. Below right, Chief Hyacinthe Andre and his wife Eliza came from Arctic Red River (now Tsiigehtchic) to greet the Queen.

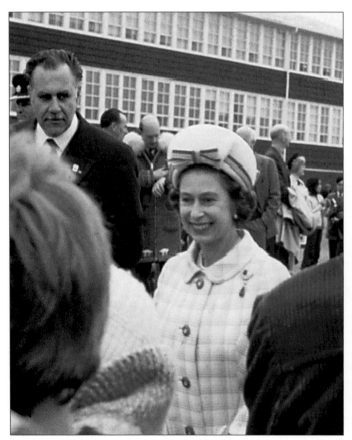

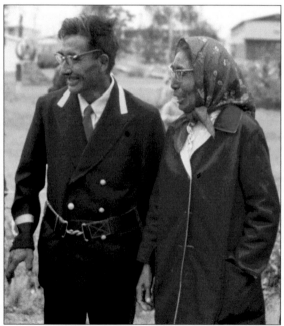

In 1966 construction began for a high school in Inuvik. There was a strong movement to have the school named "Anisaluk" after Charlie Smith, a local leader who died in 1967. But the Territorial government decreed that the school would be named after Samuel Hearne, an English explorer who never set foot on the Mackenzie Delta. The school was opened in 1969 in a ceremony led by Hon. Jean Chretien, Minister of Indian & Northern Affairs.

Above, the Science Fairs in Inuvik pre-dated the establishment of a high school, with the first one conducted by 1965 by the Inuvik Research Laboratory. Below left, the Research Laboratory also hosted one of the first "distance education" programs, in 1970, with classes taught through a computer hook-up to University of Western Ontario. Below right, Father Ruyant was the supervisor at Grollier Hall, the residence for secondary students from nearby communities.

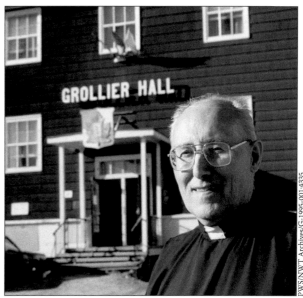

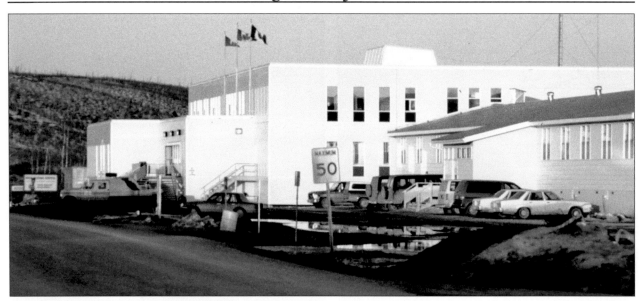

Inuvik's hospital was built in 1961, not in the centre of town as shown on the original plans, but in an east end location chosen by Ottawa bureaucrats.

Top, the smaller section on the right is the original hospital built in 1961, while the larger additional on the left dates from the 1980s.

Left, lay dispensers received training to distribute medicines in the community.

Below left, distributing medicines to children in the hospital.

Below right, nurse Barb Lennie conducts a development test with Cheryl & Brent Sharpe.

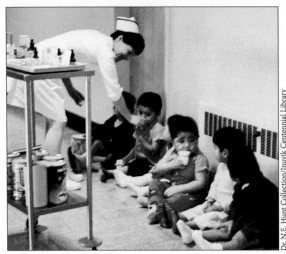

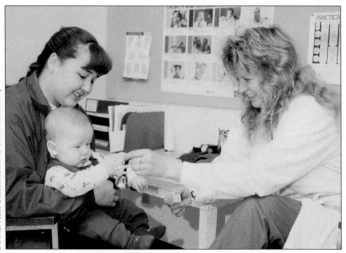

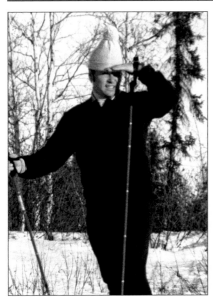 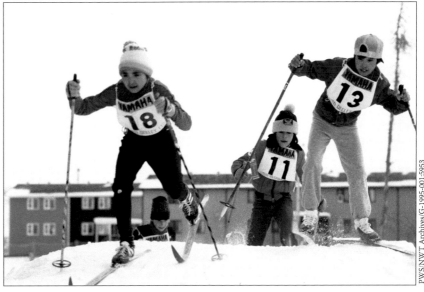

PWS/NWT Archives/G-1995-001:5953

Inuvik's recreational ski program drew many participants and hosted competitors from a wide area. Thanks to the hard work of many people – young athletes, coaches and their many supporters – Mackenzie Delta residents became a large part of Canada's national cross-country ski team. The Firth twins, Sharon & Shirley, were the most famous alumni of the program – they went on to represent Canada in the Olympics.

Top left, Bjorger Petersen, coach of the Territorial Experimental Ski Training (TEST) program.

At right, Sharon & Shirley Firth at the Winter Olympics in Sarajevo, Yugoslavia, 1984.

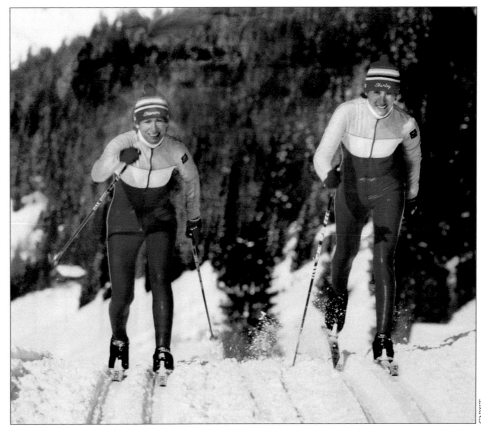

GNWT

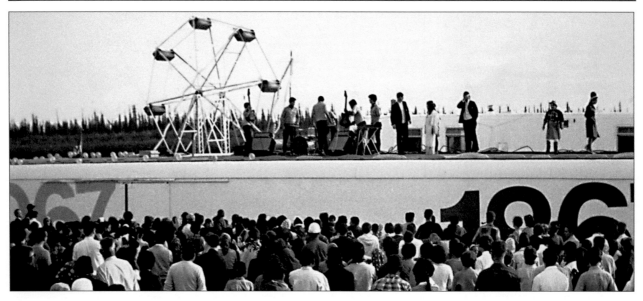

Townspeople found lots of ways to pass the time. During the NWT Centennial in 1970, a barge in the river hosted a community party. Bingo quickly became a very popular activity, which kept some people busy nearly every night of the week.

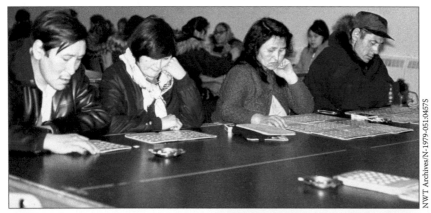

NWT Archives/N-1979-051:04575

Avid golfers found ways to create new courses, whether on the tundra in summer, as below, or on ice in winter.

Below centre, Inuvik hosted an international bonspiel in 1981.

Below left, racing a snowmobile across open water was one way to have fun as winter ice melted.

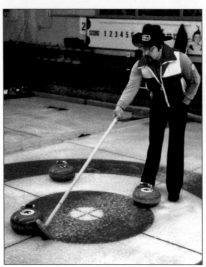

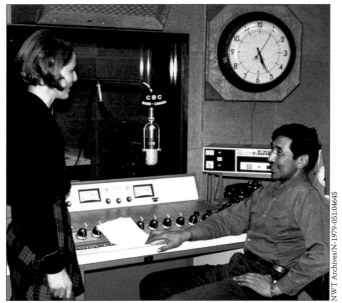

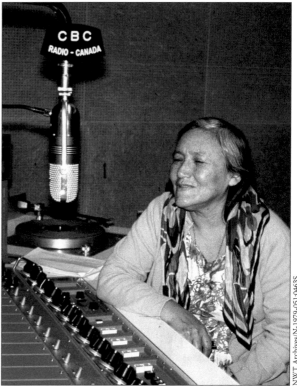

Radio and TV not only brought Inuvik news of the outside world, but also helped residents communicate send messages to relatives in other Mackenzie Delta towns.

Above left, Nellie Cournoyea and Edward Lennie both worked for CBC Inuvik in 1970. Above right, announcer Sarah Gardlund at the CBC in 1970. Below, Dennis Cichelly was one of the first announcers at Inuvik TV. Below right, John Boudreau was a cameraman for Inuvik TV.

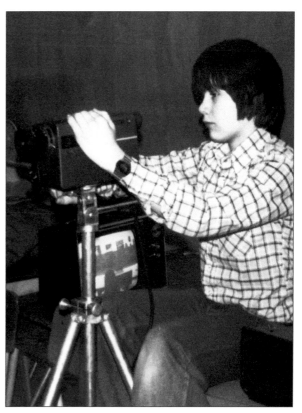

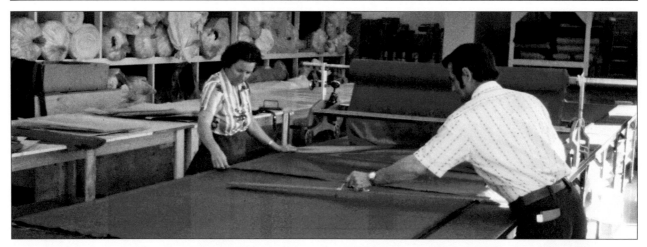

Merchants had set up shop in Inuvik almost as soon as the first buildings were constructed, and over the years a wide variety of new businesses took root.

Above, one of the first manufacturing operations in Inuvik made distinctive Mackenzie Delta parkas.

At right, the Knox Brothers Food Barn was one of the companies that met local demand for bulk purchases of staple foods.

Below, L.F. "Slim" Semmler set up the first store at East 3 in a tent in 1956, and his store on Mackenzie Road was the third commercial building in Inuvik.

Below right, Northern Images was set up in response to a strong demand from visitors for arctic arts and crafts.

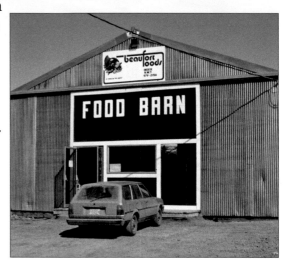

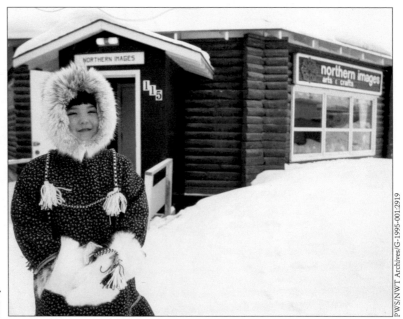

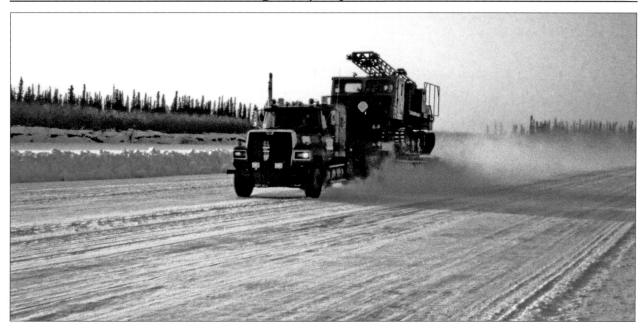

From the early days, the Mackenzie River was a natural highway to Inuvik, and it was well travelled in summer and winter.

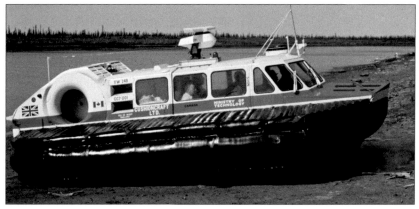

Above, the snow was cleared from a wide strip of the Mackenzie Delta channels each winter. With no insulating blanket of snow, the ice would freeze to a depth of 5 feet or more. From December to April each year, cars and trucks could travel between Inuvik, Aklavik and Tuktoyaktuk.

Centre left, an amphibious hovercraft was tested on the Mackenzie Delta but proved to be of limited utility.

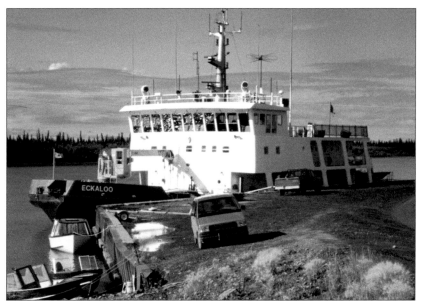

Left, Transport Canada's Eckaloo, a buoy boat, set out markers for shipping channels each spring. Much of the community's freight was brought in on barges which travelled down the Mackenzie from Hay River.

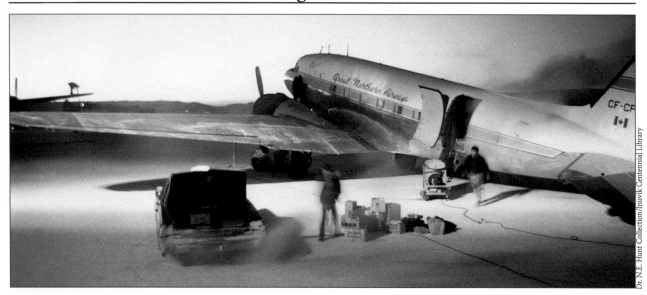

Dr. N.E. Hunt Collection/Inuvik Centennial Library

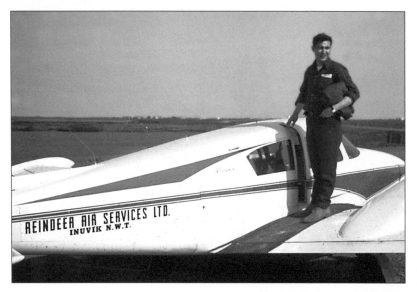

Inuvik's major airstrip (bottom left) handled the large aircraft that flew to Yellowknife, Edmonton and Calgary. But an in-town airport was constructed right beside the East Channel, to handle flights to and from other delta communities. Float planes were also in common use.

Left, Fred Carmichael, one of Inuvik's prominent business and political leaders, started Reindeer Air Services in 1956.

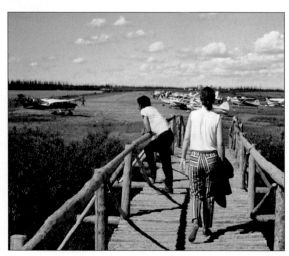

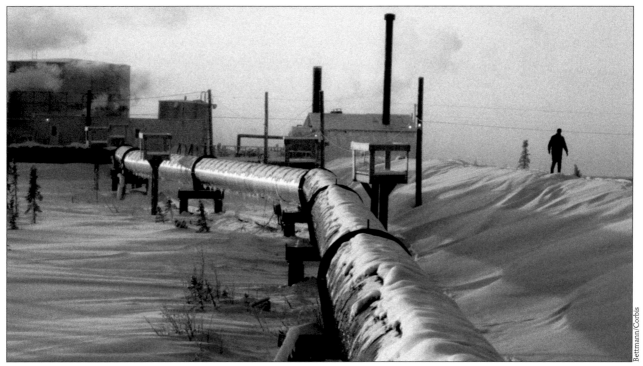

By the mid 1970s, Inuvik became a flourishing hub for oil and gas exploration, and the thriving business community prepared for the construction of a major pipeline. But business in Inuvik took a sharp downturn after the release of the Berger Report in 1977. Mr. Justice Thomas Berger (below right) had been appointed to provide the terms and conditions for constructing a Mackenzie Valley gas pipeline. After three years of hearings, he recommended a ten-year moratorium on any pipeline construction. The moratorium, coupled with a drop in petroleum prices in the 1980s, put an end to most exploration activity in the Inuvik region, and there were no major new initiatives until the turn of the century.

Top, a 48" hot oil experimental pipeline was built at the north end of Inuvik to see how well pipeline techniques could be adapted to arctic conditions. Below left, an exploratory well was drilled in 1969 just north of Inuvik along Navy Road.

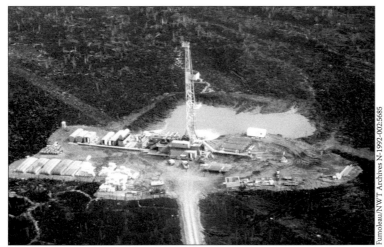

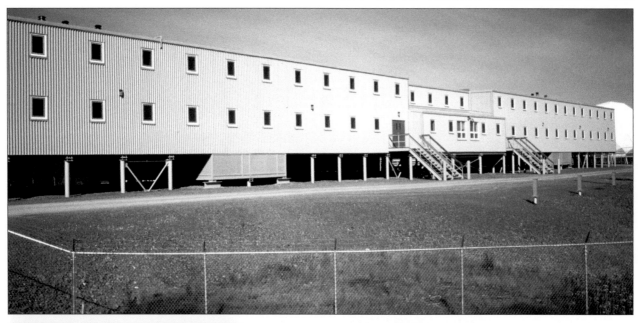

Inuvik suffered another blow in the mid-1980s, when the federal government announced the closing of CFS Inuvik, at that time the largest military base in the north. The closure resulted in nearly 700 people leaving town. Inuvik was named the site of the Forward Operating Location for F-18 aircraft, but this facility is used only occasionally for military exercises, and there is little local employment in construction or operations.

Top, the Forward Operating Location base near the Inuvik airport.

At left, the official crest of Canadian Forces Station Inuvik.

Bottom left, a plaque erected to commemorate CFS Inuvik.

Below, a Canadian Forces Hercules at the Inuvik airport.

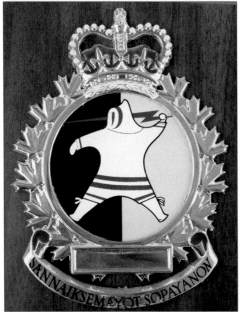

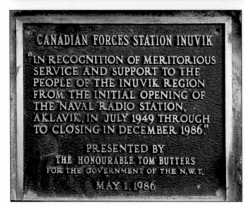

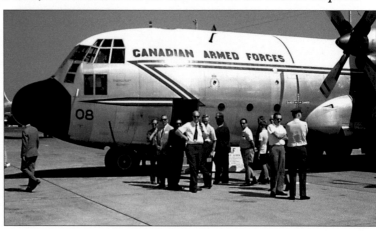

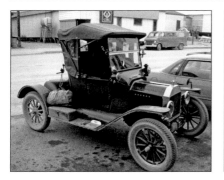
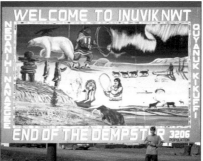

The Dempster Highway – long hailed as the "Road to Resources" was finally completed in 1979, shortly before the petroluem-exploration entered a decades-long slump. But the 742-kilometre gravel road soon became a magnet for adventurous motorists, attracted to the opportunity to drive beyond the Arctic Circle. Since the opening of the Highway, tourists have come to Inuvik in motorhomes, four-wheel drive pick-up trucks, bicycles, and even a well-travelled Model T.

The opening of the Dempster was a boon to the local tourism industry, as many of the people who stayed in Inuvik's campgrounds also booked local tours by boat and plane.

Below, a small plane mounted as a wind vane outside the Western Arctic Tourism Centre.

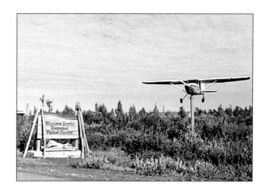

Below, campers at the Chuk Territorial Campground just south of Inuvik.

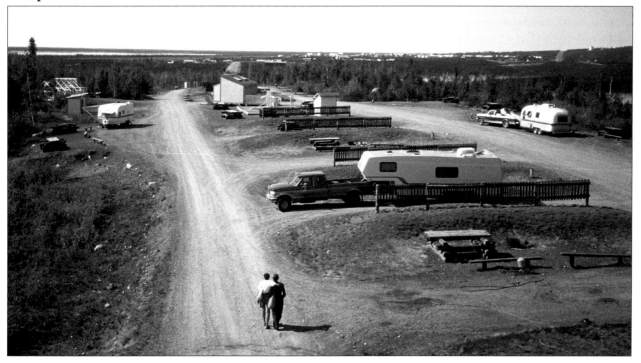

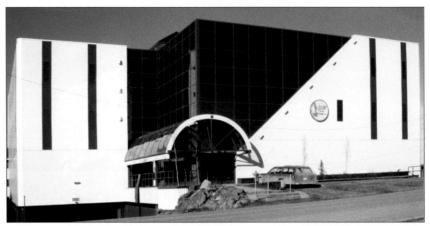

The first native land claim in the arctic was settled in 1984, and the Inuvialiut Regional Corporation (IRC) established its headquarters in Inuvik. In 1992, the Gwich'in Tribal Council (GTC) signed a land claim, and although their headquarters moved to Fort McPherson, Inuvik remained the site of major GTC subsidiaries. The signing of these land claims brought an infusion of new cash into the region, created new educational and cultural programmes, and offered greater certainty to other businesses considering investments in the area.

Top left, Roger Gruben, a well-known Inuvialuit businessman from Tuktoyaktuk, became president of the Inuvialuit Regional Corporation, whose headquarters (top right) on Mackenzie Road stood out as one of the most impressive structures in Inuvik. Above right, Nellie Cournoyea took over as president of the IRC in 1996.

Bottom right, aviator and entrepreneur Willard Hagen was president of the Gwich'in Tribal Council when they signed their land claim in 1992. One result was the construction of the Chief Jim Koe Building, on the site of the former Council Crescent. The new building was the office of the Inuvik Native Band and the Gwich'in Land and Water Board. At right, another regional aviation pioneer, Fred Carmichael, became president of the Gwich'in Tribal Council in 2000.

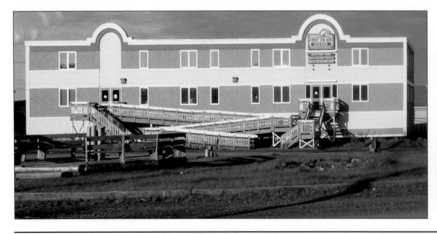

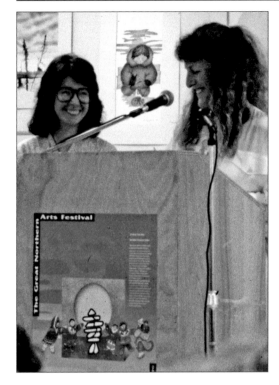 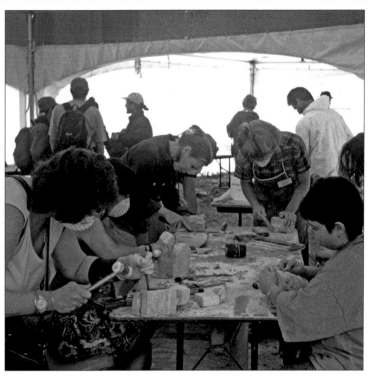

The Inuvik region had always enjoyed a strong arts scene. In 1988, with the founding of the Great Northern Arts Festival (GNAF), the arts also became a strong tourist draw, as people came from across Canada to be a part of a ten-day celebration of northern arts.

Above left, Sue Rose and Charlene Alexander, co-founders of the Great Northern Arts Festival. Above right, a carving workshop at the Festival, one of many settings in which both experienced and beginning artists could learn new techniques.

Below left, carver Angus Cockney. Below centre, weaver Rhoda Veevee. Below right, a painting by popular local artist William Bonnetplume.

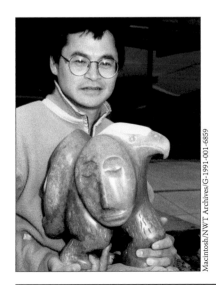 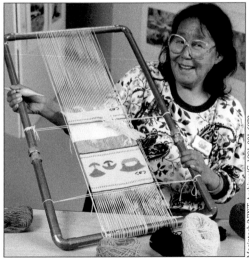 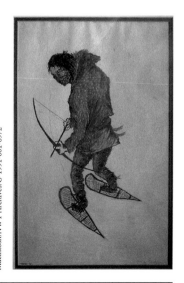

Macintosh/NWT Archives/G-1991-001-6859

Macintosh/NWT Archives/G-1991-001-6972

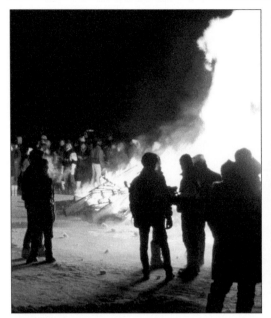
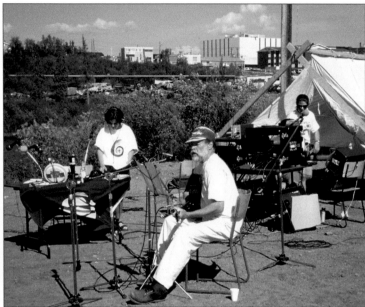

Winter and summer, Inuvik residents found new ways to celebrate. In 1987, one of the community's most famous annual parties was born – the Sunrise Festival, held each year on January 6 to celebrate the impending return of the sun after a month-long absence.

Above left, revellers warm up around a bonfire on the ice of Twin Lakes, before watching a fireworks display in the Sunrise Festival. Above right, Bob Mumford performs at a CBC riverfront broadcast. Below, the blanket toss during the tenth-anniversary celebration of the Inuvialuit Land Claim in 1994.

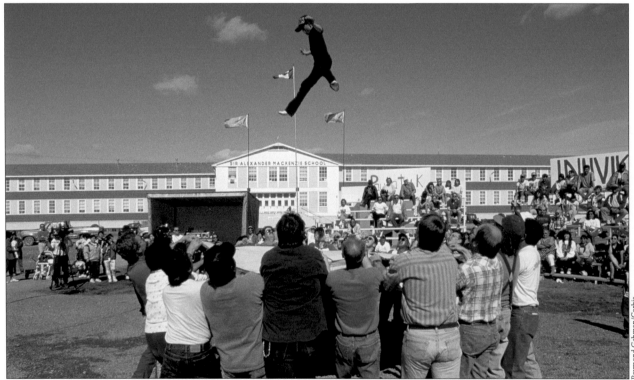

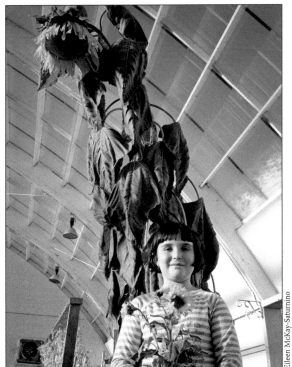

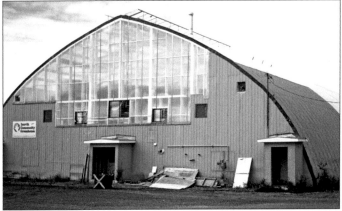

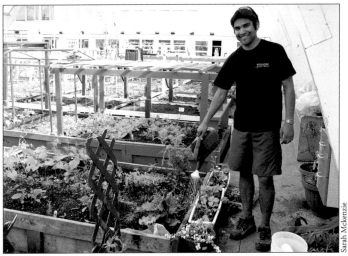

The Inuvik Community Greenhouse was begun in 1998 in the former Grollier Hall arena. The facility hosts garden plots for community members as well as a commercial greenhouse. The Inuvik Family Centre, below, was completed in 2005 at a cost of $8.5 million. It features a 120-foot waterslide, and the swimming pool, with a stainless-steel liner, is built on permafrost.

Top left, Carina Saturnino in the Greenhouse, autumn 2007. Above, Jonathon Michel tending to one of the plots.

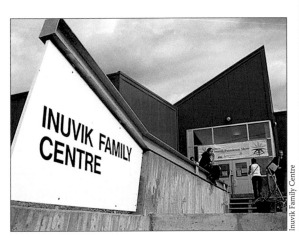

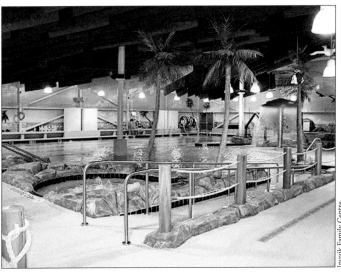

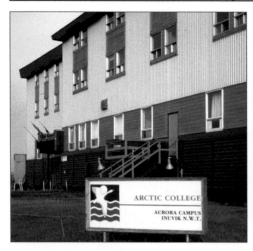
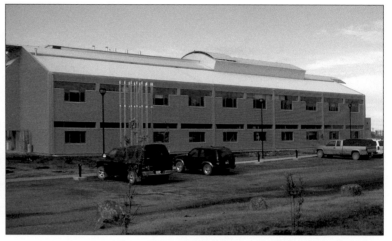

The Aurora Campus of Arctic College was originally located in the former headquarters of the Canadian Forces Station Inuvik (above left). But at the turn of the millenium, the Government of the Northwest Territories decided it was time for a new and expanded Aurora Campus. The new building (above right) was completed in the summer of 2004. The Campus offers programs in health care, teacher education, natural resources, trades and management.

In the 1990s, Inuvik TV branched out from cable TV to become the first internet service provider in the region (and a world pioneer in high-speed internet access, at a time when such access was still rare in major metropolitan areas). The company moved a geodesic dome from the abandoned Distant Early Warning (DEW) station in Tuktoyaktuk, and refurbished it to serve as the office for Inuvik TV and New North Networks.

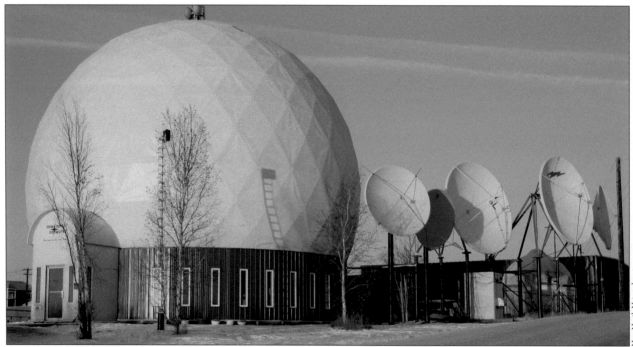

New North Networks

The Petroleum Industry Returns

In the first decade of the 21st century, the exploitation of energy resources is once again at the top of the agenda in Inuvik. With natural gas prices climbing steadily, major oil companies started a new round of planning for a pipeline up the Mackenzie Valley to Alberta. This time, the Inuvialuit and Gwich'in development corporations are partners in the planning and will have an ownership share of any pipeline that may be built.

At right, Inuvik Gas Ltd. operates the first commercial gas pipeline in arctic Canada. Constructed by the Inuvialuit Petroleum Corp. in association with Enbridge, the pipeline brings gas from the Ikhil field about 50 km north of Inuvik to residential customers as well as the NWT Power Corporation.

Below, Rosie Albert and Robert Kuptana translate the proceedings of the Joint Review Panel into the proposed Mackenzie Valley natural gas project into Gwich'in and Inuvialuktun during hearings in February, 2006.

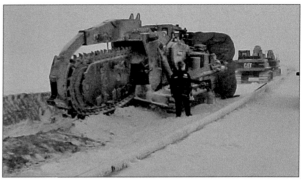

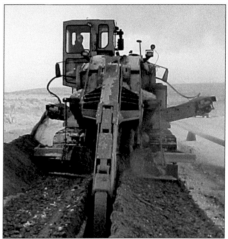

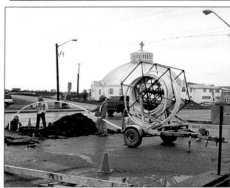

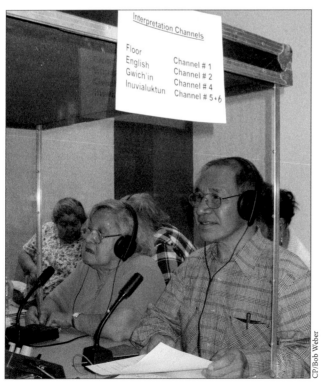

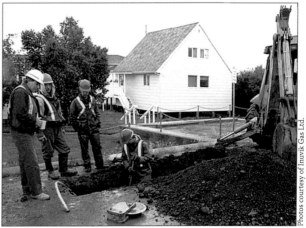

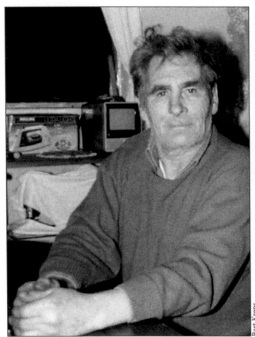

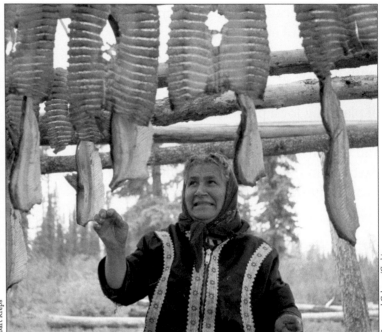

In the 1950's, Jimmy Adams, above, had a registered trapline in the area that became East 3 and then Inuvik. The Jimmy Adams Peace Park is named in his honour. His wife Lucy, shown here making dried whitefish at their camp on the East Channel in 1994, provided a glimpse of Delta hospitality for many tourists over the years.

The past 50 years have seen a renewal of the Inuvialuit tradition of drum dancing. Among the Inuvik elders who helped bring this about were Alex Gordon, below left, and Martha Harry, who was honoured with a Canada Post stamp in 1999.

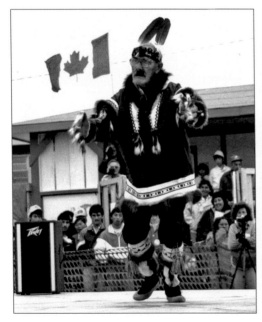

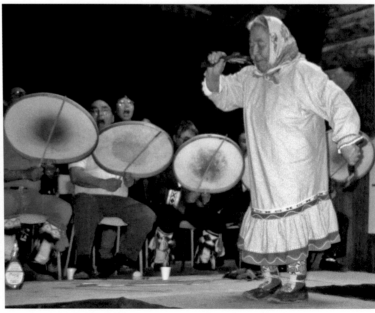

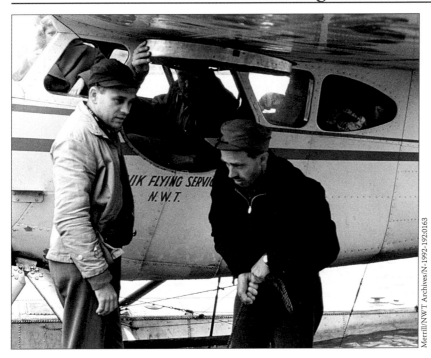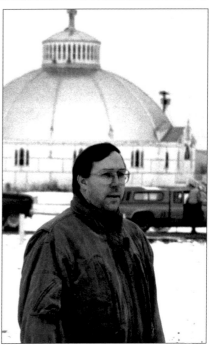

Top left, pilot Mike Zubko with FENCO engineer Norm Lea in 1955. Mike founded Aklavik Flying Service, and today the main Inuvik airport is named in his honour. Son Tom Zubko, top right, has been active in Inuvik business and politics since the 1970s, and owns Inuvik TV and NewNorth Networks.

Below right, Inuvik resident Floyd Roland worked for the Department of Public Works as a mechanic in 1991. Sixteen years later, in October of 2007, he was all smiles after his fellow Members of the Legislative Assembly elected him as premier of the Northwest Territories.

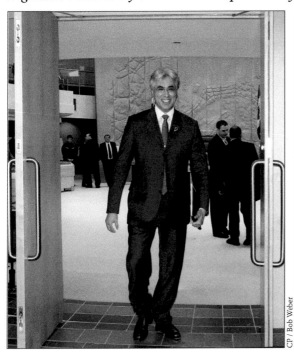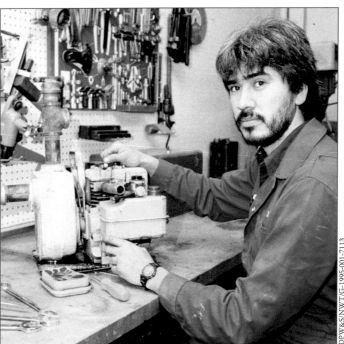

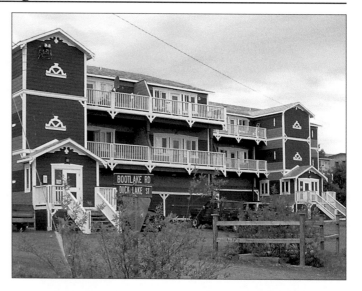

Above, the original Boot Lake Apartment complex. Above right, the complex was extensively renovated in the 1990s.

Below, the original Inuvik Centennial Library, which later became the Inuvik Youth Centre, after the Library moved into a new building (right) in 1996.

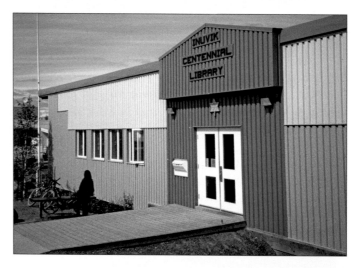

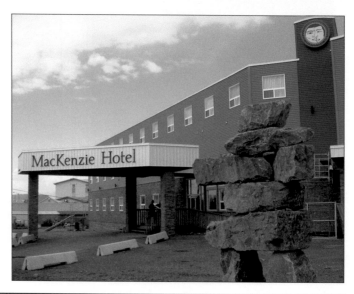

Above, the original MacKenzie Hotel in the 1960s. Right, the MacKenzie in June 2006, after the old building was replaced.

Above, the original 1961 building for the Anglican Church in Inuvik, on the left, was incorporated into a new complex which was opened in 1999.

Right, Bill & Rhoda Kikoak & family, 1994. Originally from Alaska, Bill worked as a reindeer herder out of Reindeer Station before moving to Inuvik. He was active in the Pentecostal Church, and owned Arctic Clean caretaking services.

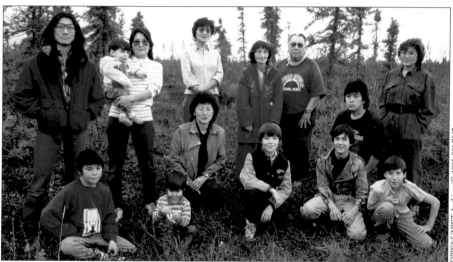

Below, the George and Martha Harry and family in 1994. George was on the original Inuvik construction team. George and Martha were active in Inuvialuit Drum Dancing.

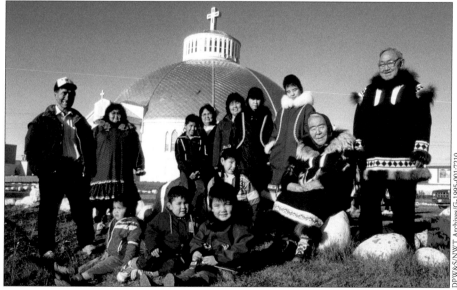

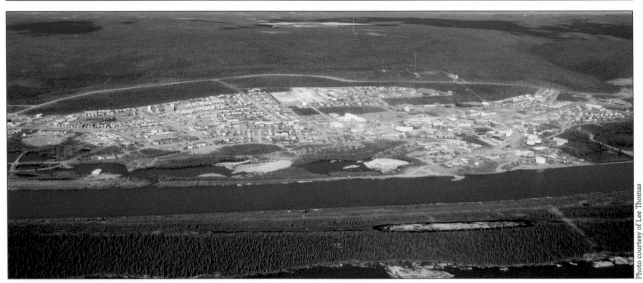

An aerial photo, taken in June 2007 from the west over the Mackenzie Delta, and looking east over the town, shows that the town's layout has changed very little since the late 1970s, even though many buildings have been replaced.

Satellite data acquired in 2007, recorded from directly overhead at an altitude of 700 kilometres, shows built-up areas in white. The town is near the top left of the image, the main airport is in the lower centre, and the Dempster Highway curves around the north end of Campbell Lake at the lower right of the image. Rocky outcrops across from Airport Lake, in the bottom centre of the image, also show in white. Flowing, silty water is light greyish blue, while settled water in lakes shows as deep blue.

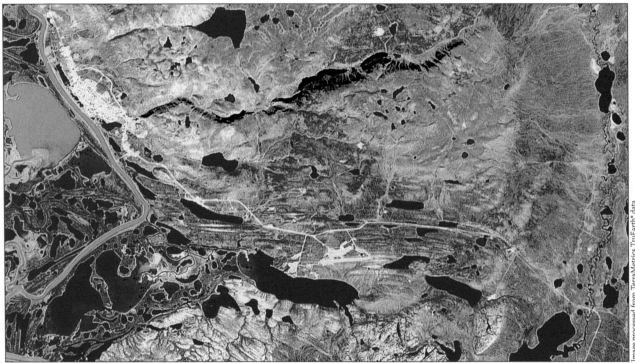

Printed in the United States
By Bookmasters